JUST ADD COLOR

DAY OF THE DEAD

30 ORIGINAL ILLUSTRATIONS
TO COLOR, CUSTOMIZE, AND HANG

ARTWORK BY SARAH WALSH

Rockport Publishers
100 Cummings Center, Suite 406L
Beverly, MA 01915

rockpub.com • rockpaperink.com

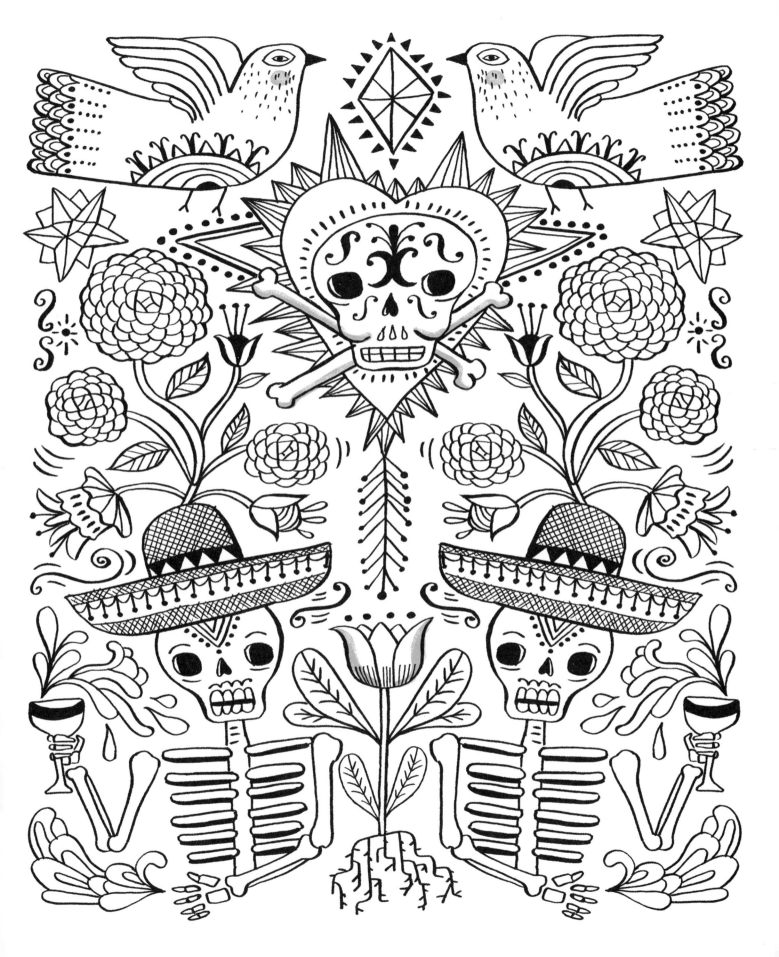

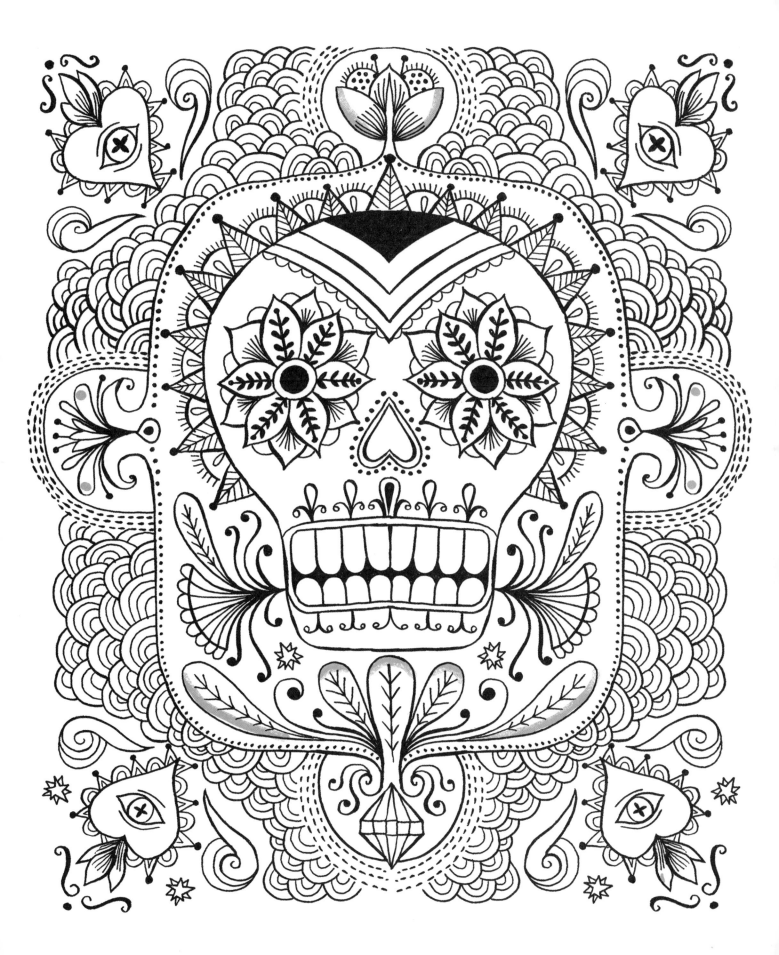

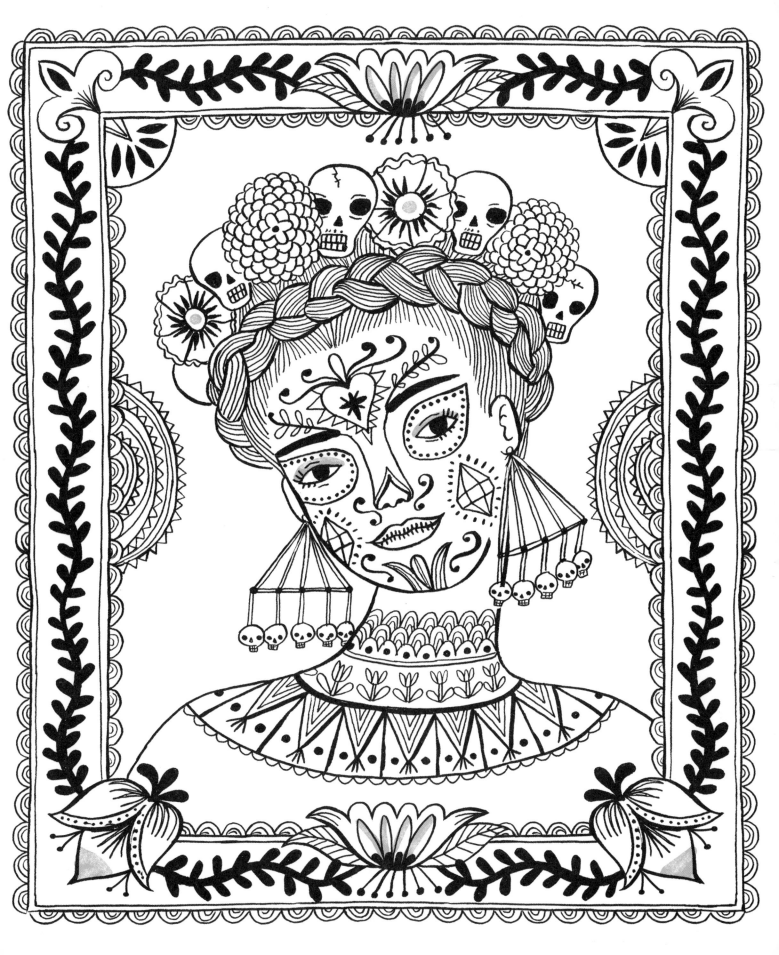

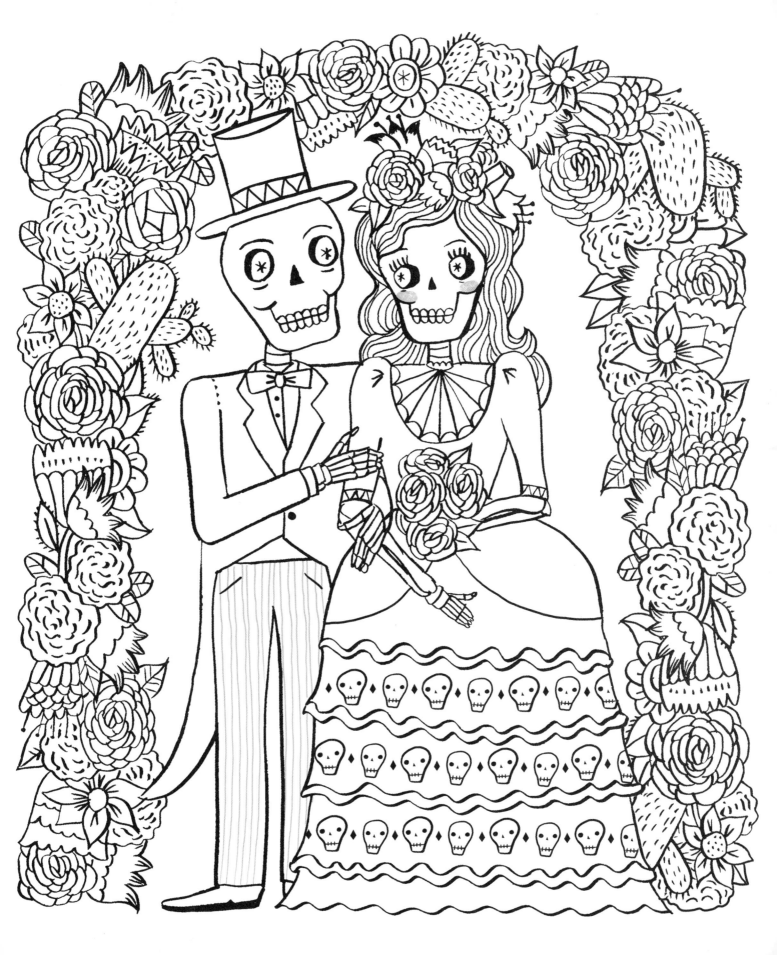

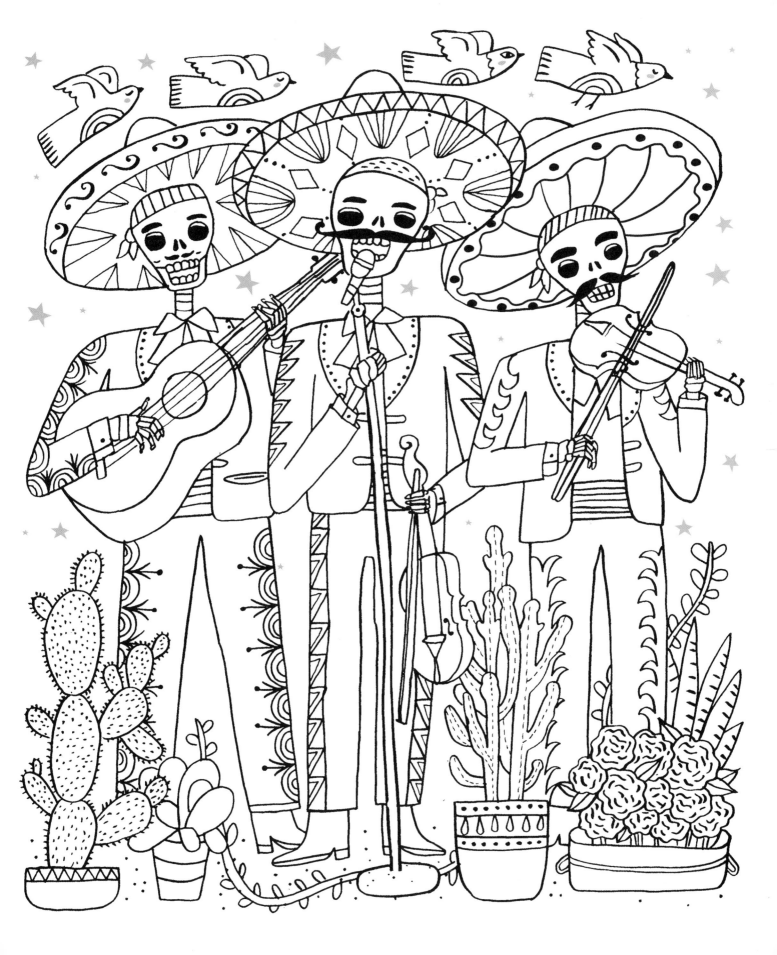

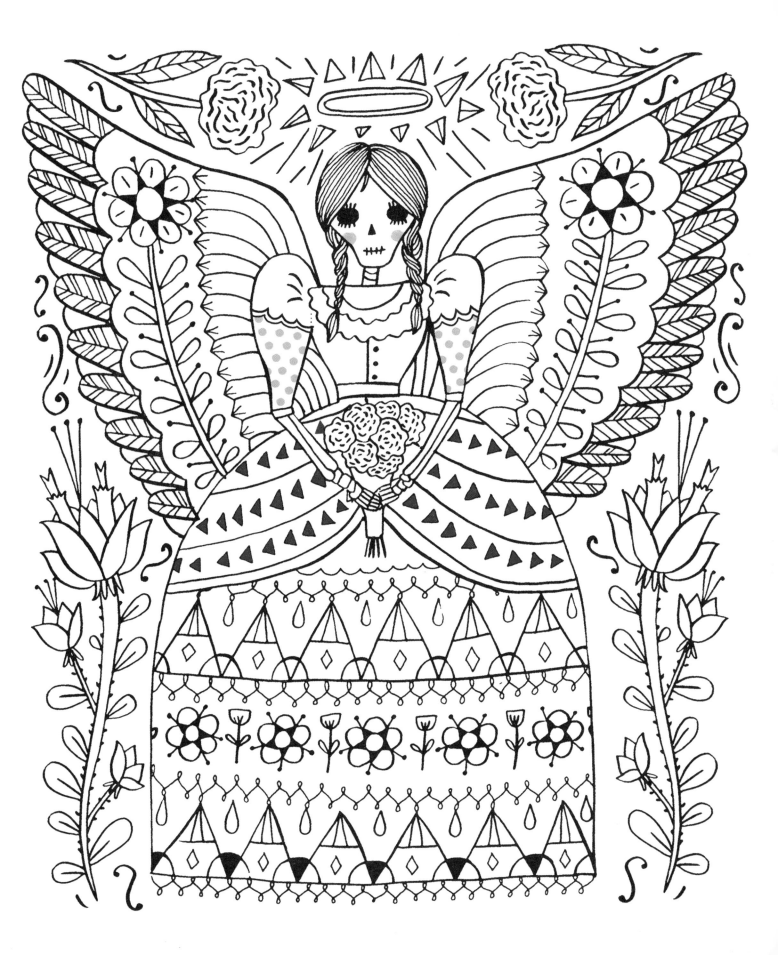

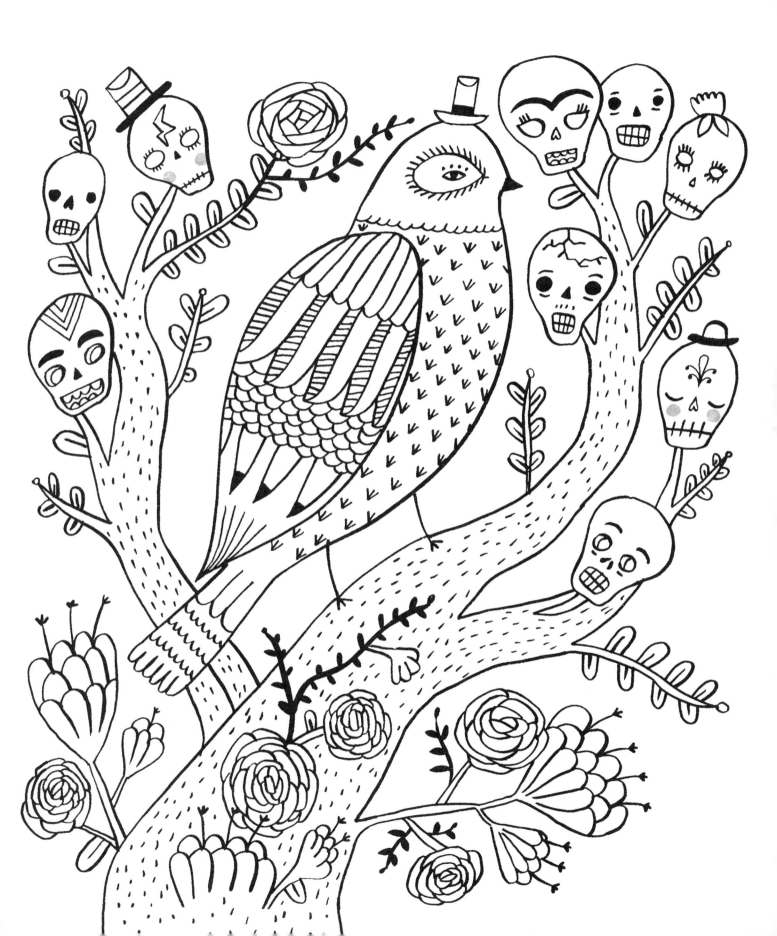

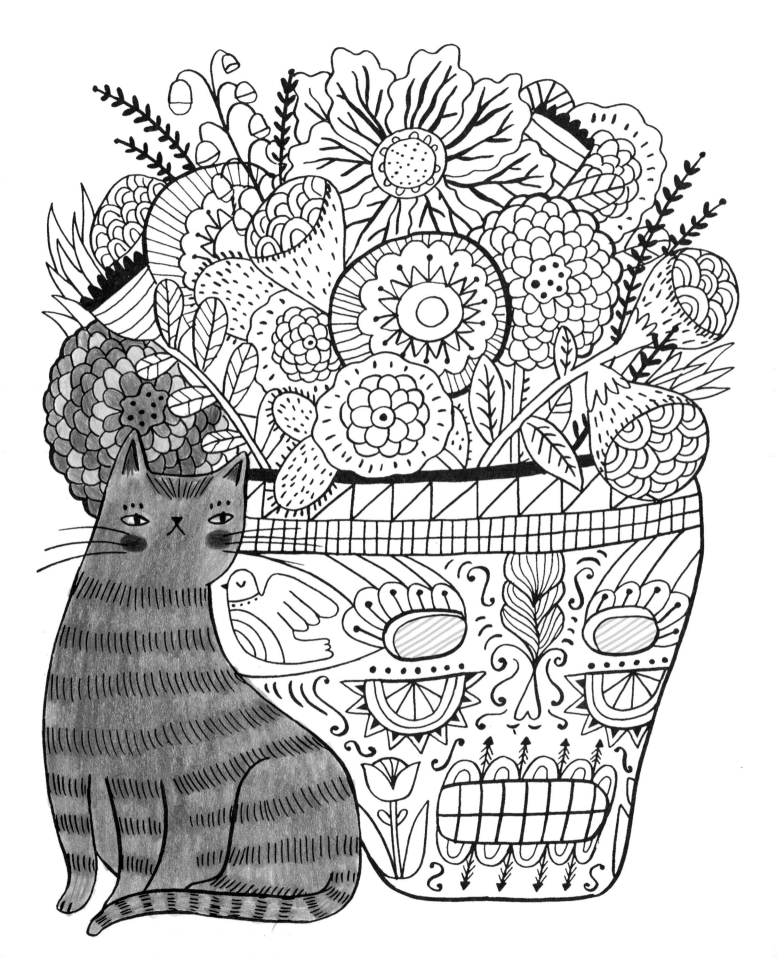

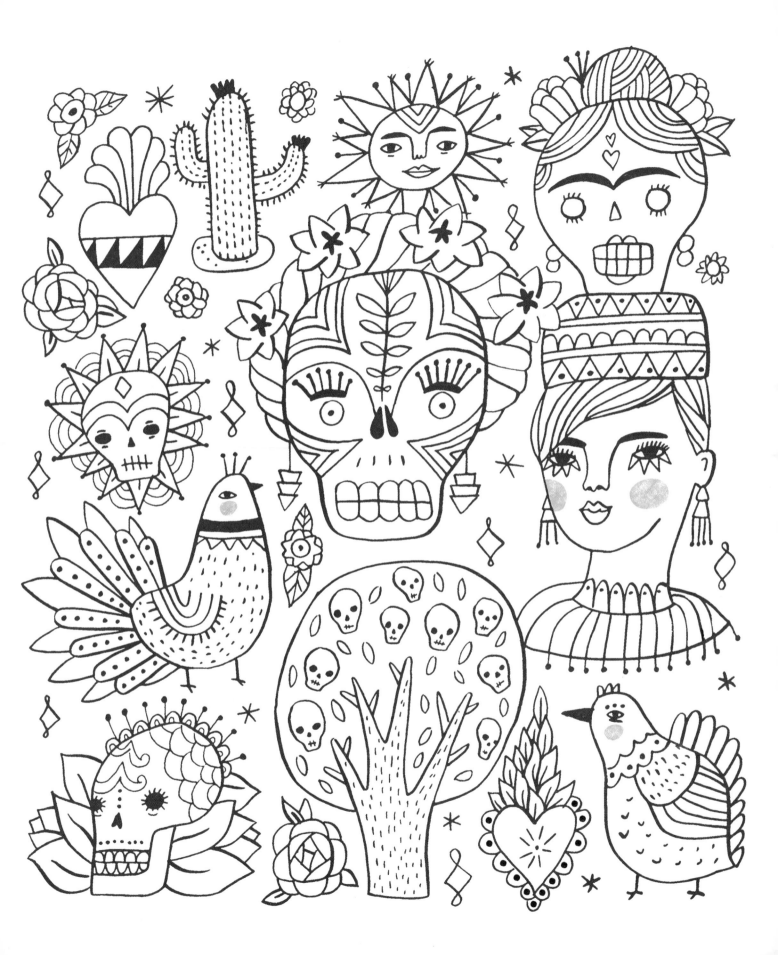

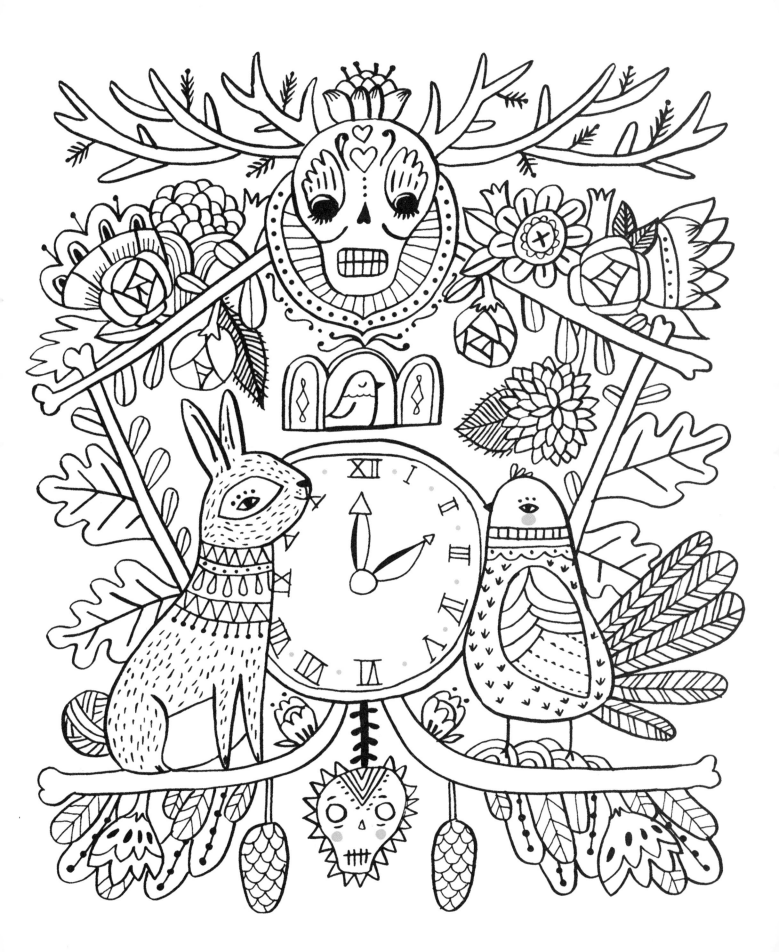

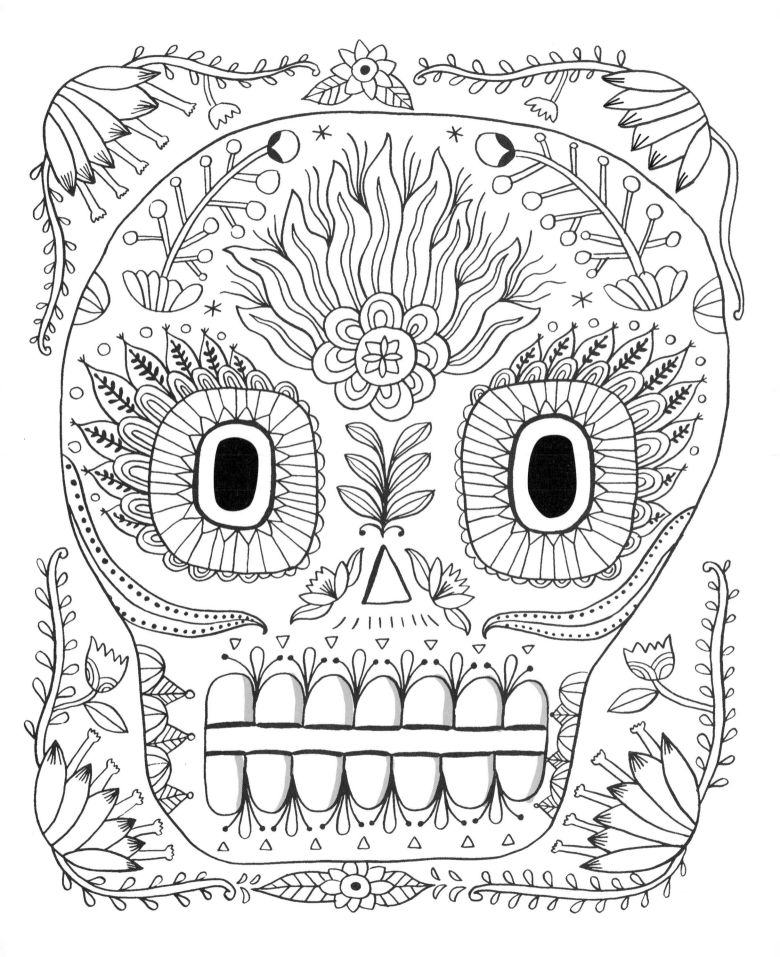

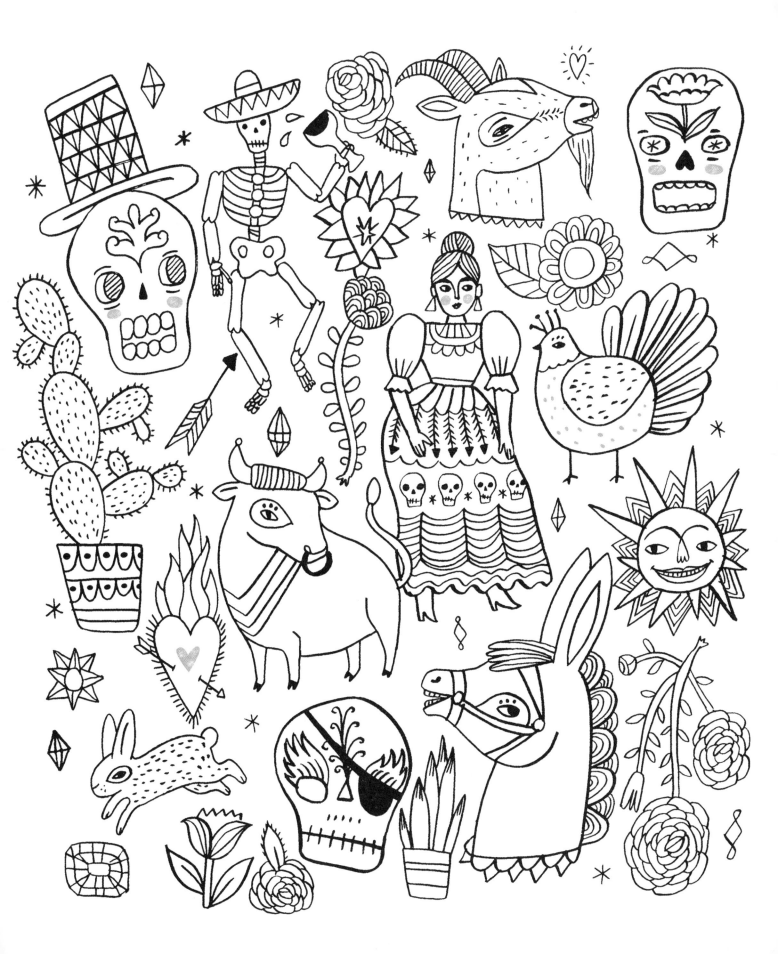

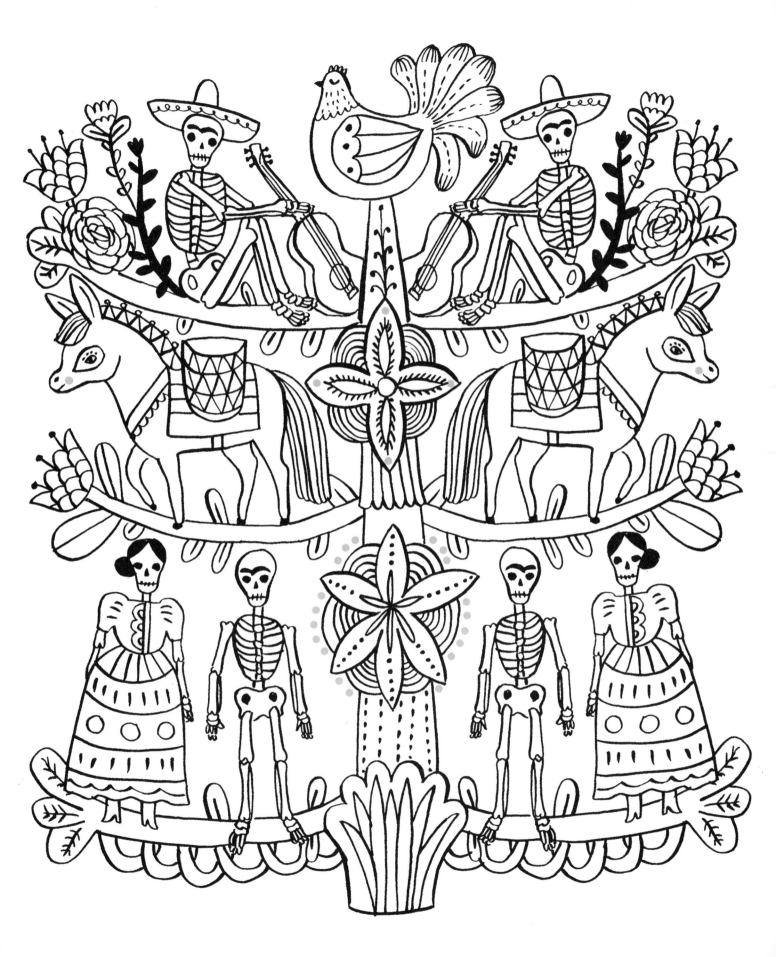

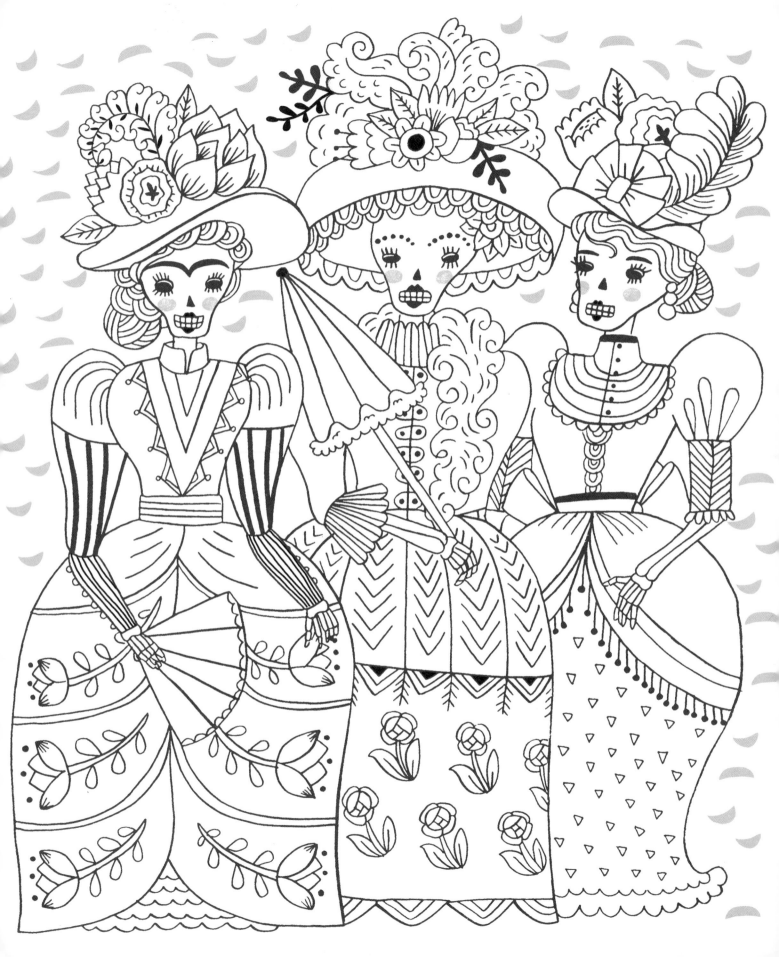

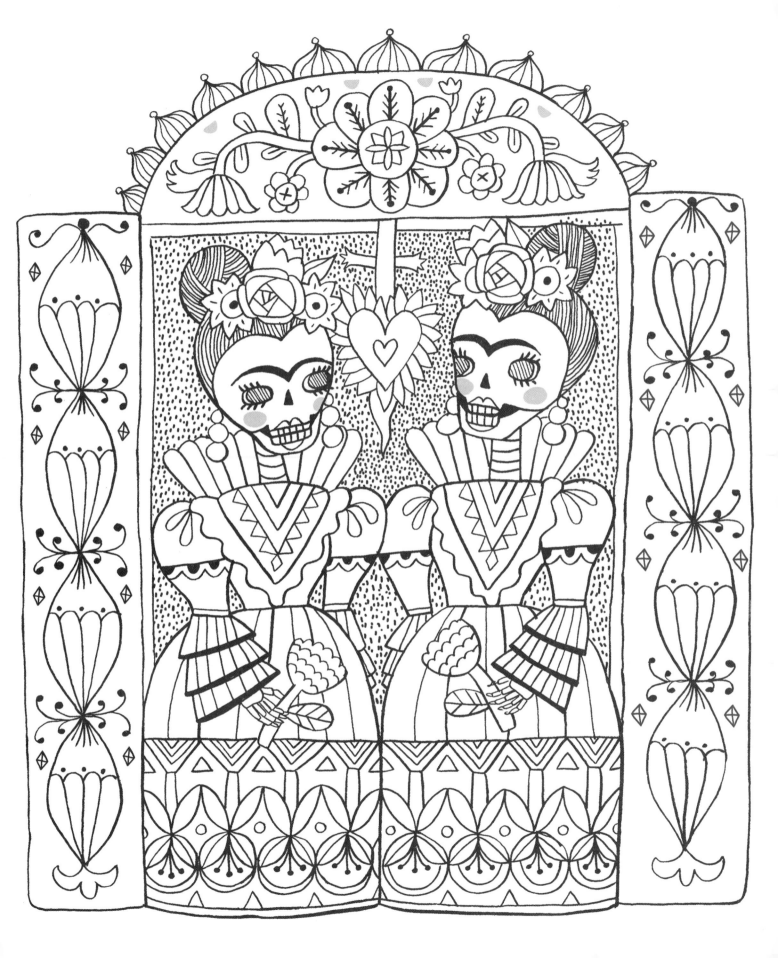

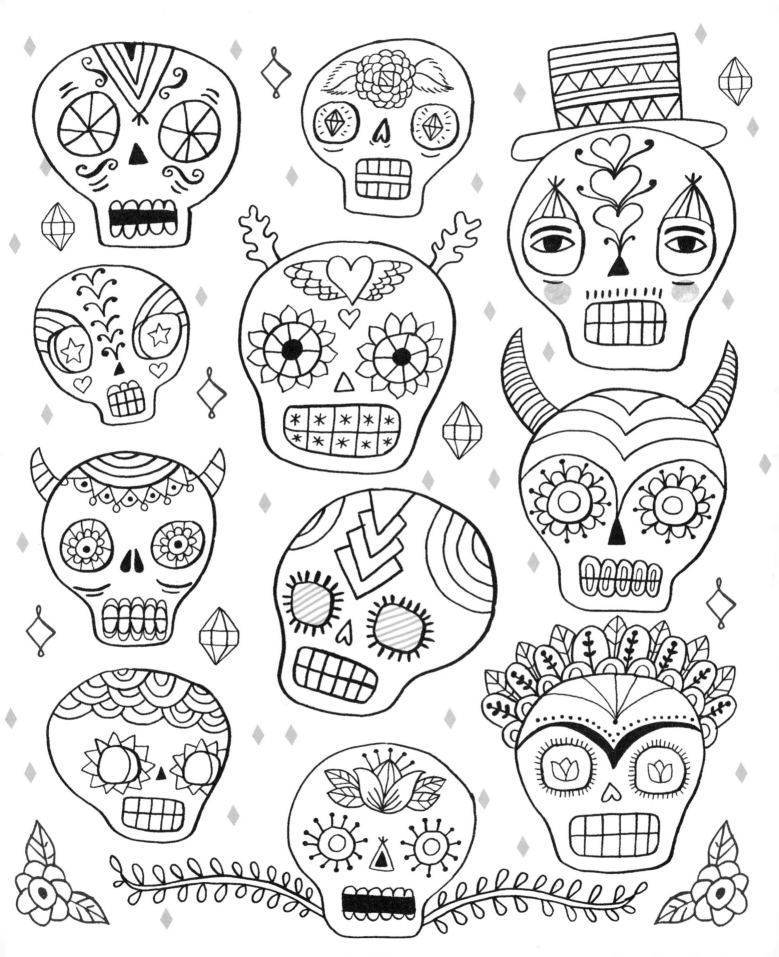

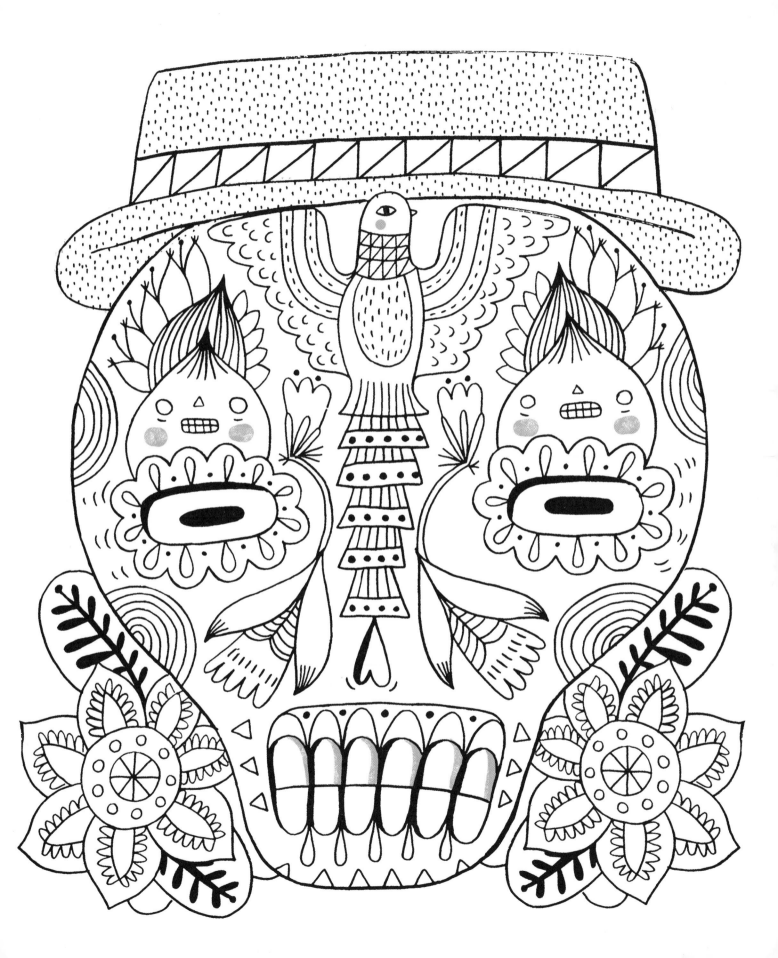

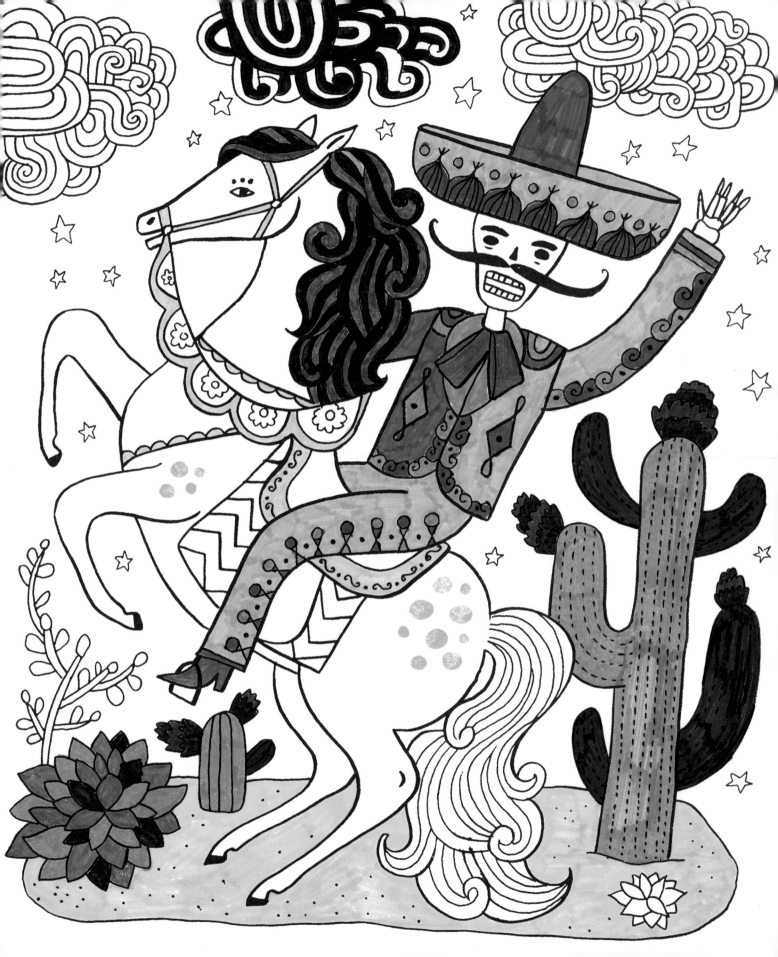

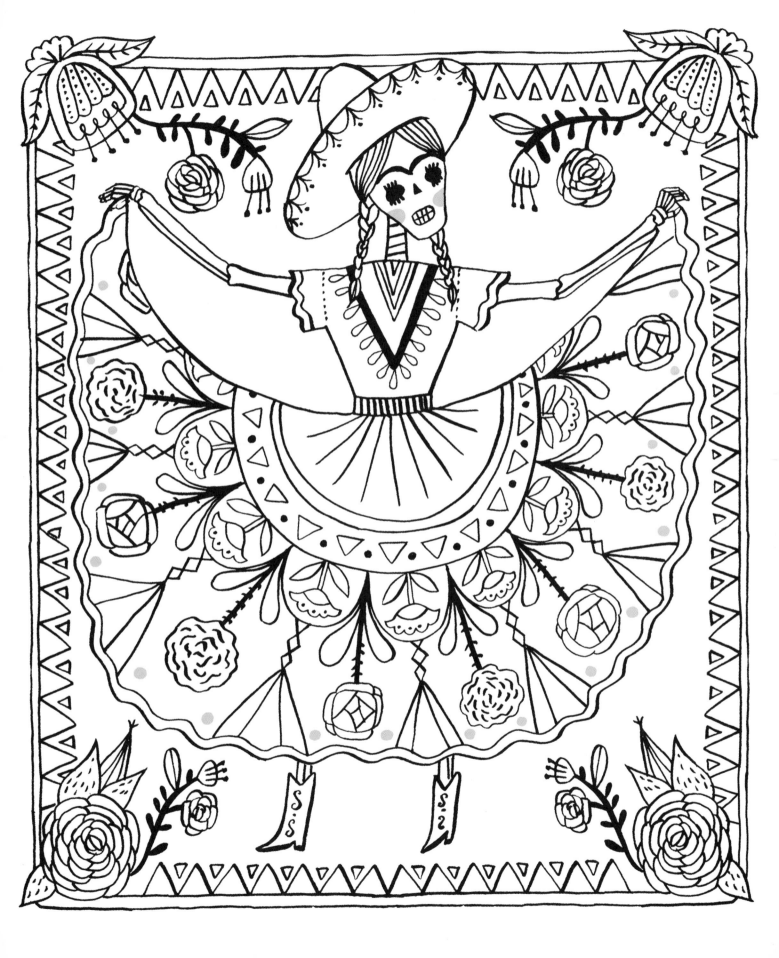

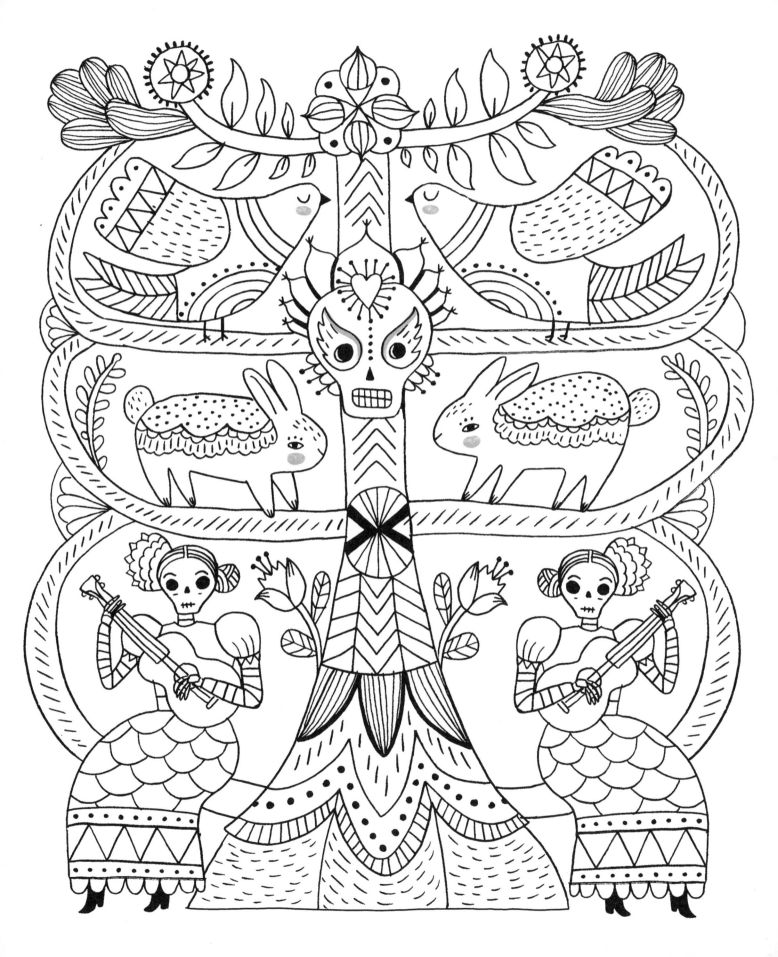

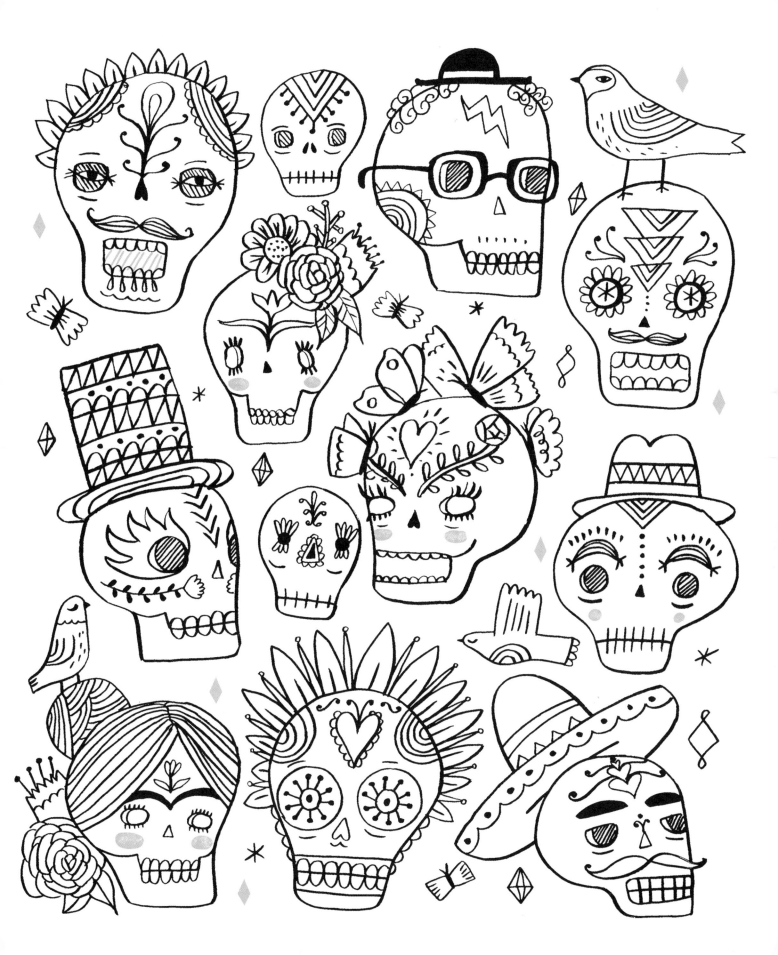

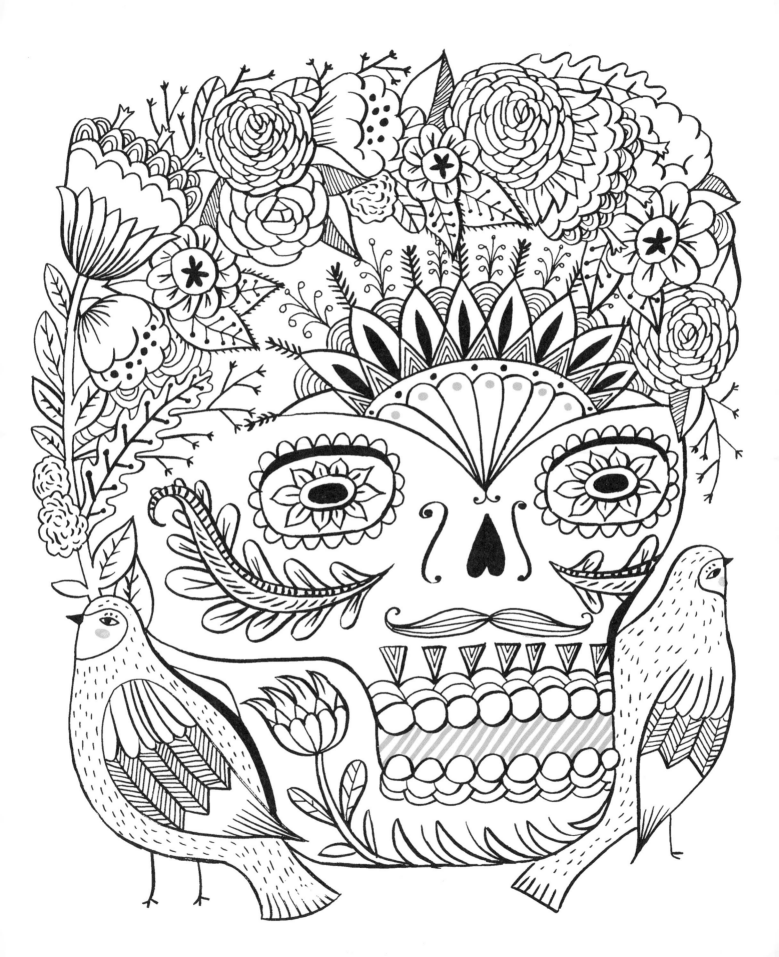

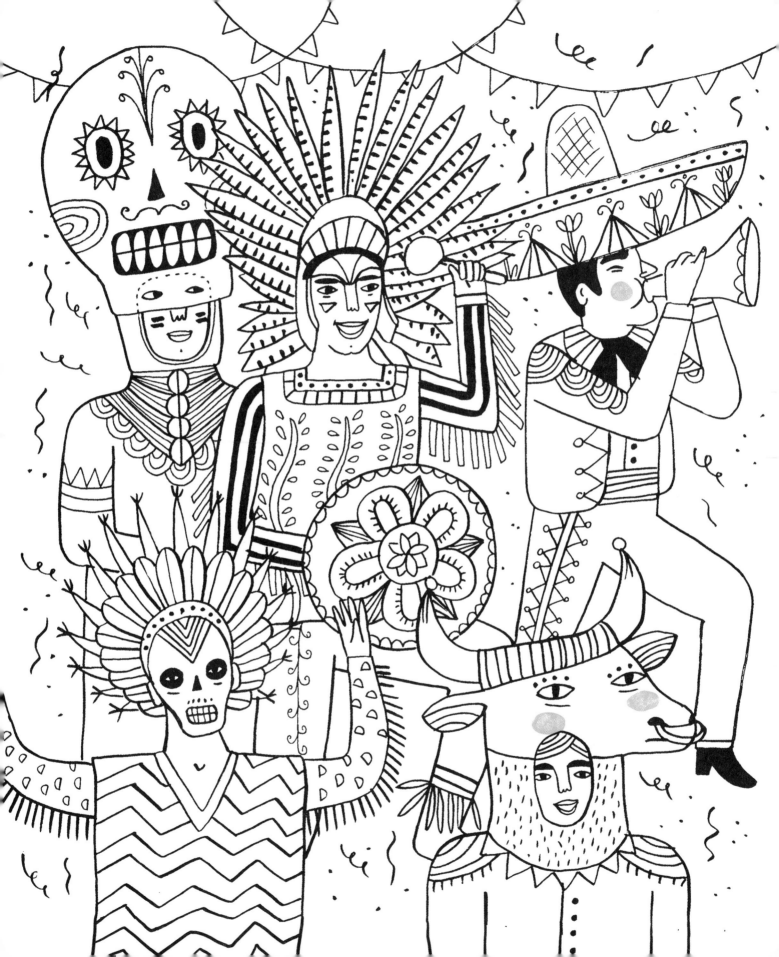

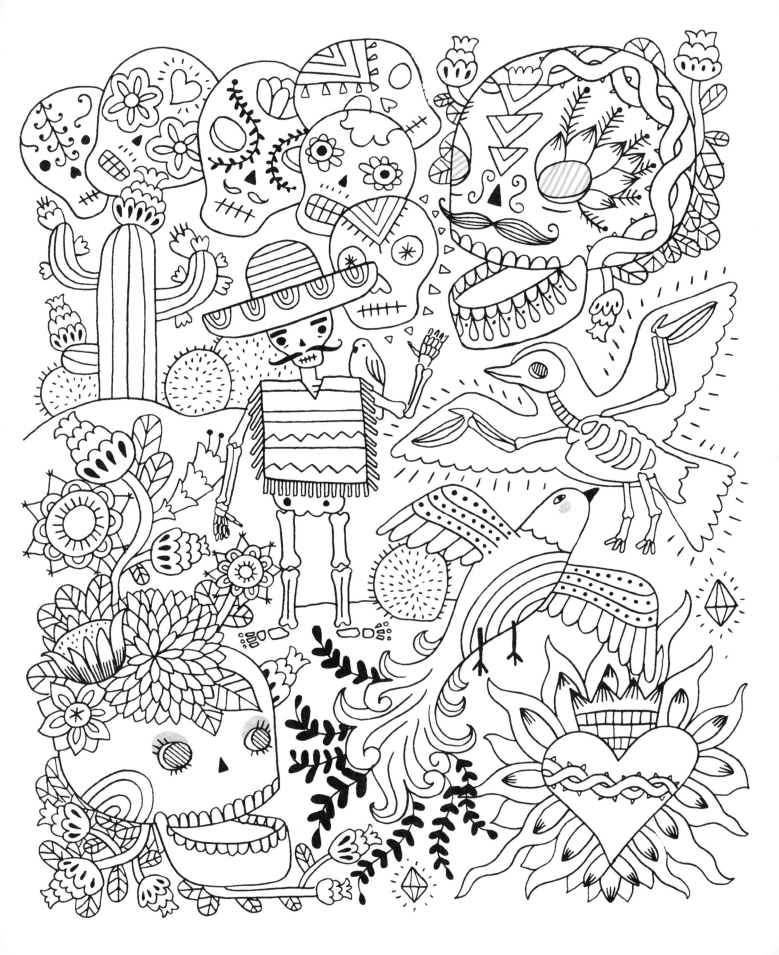

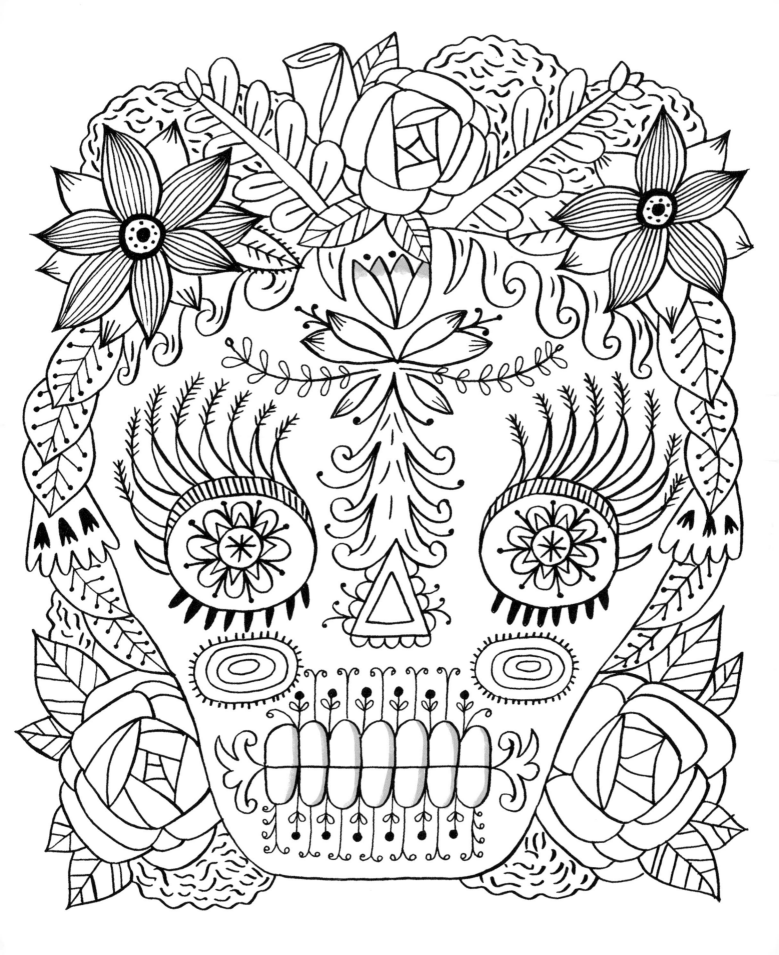

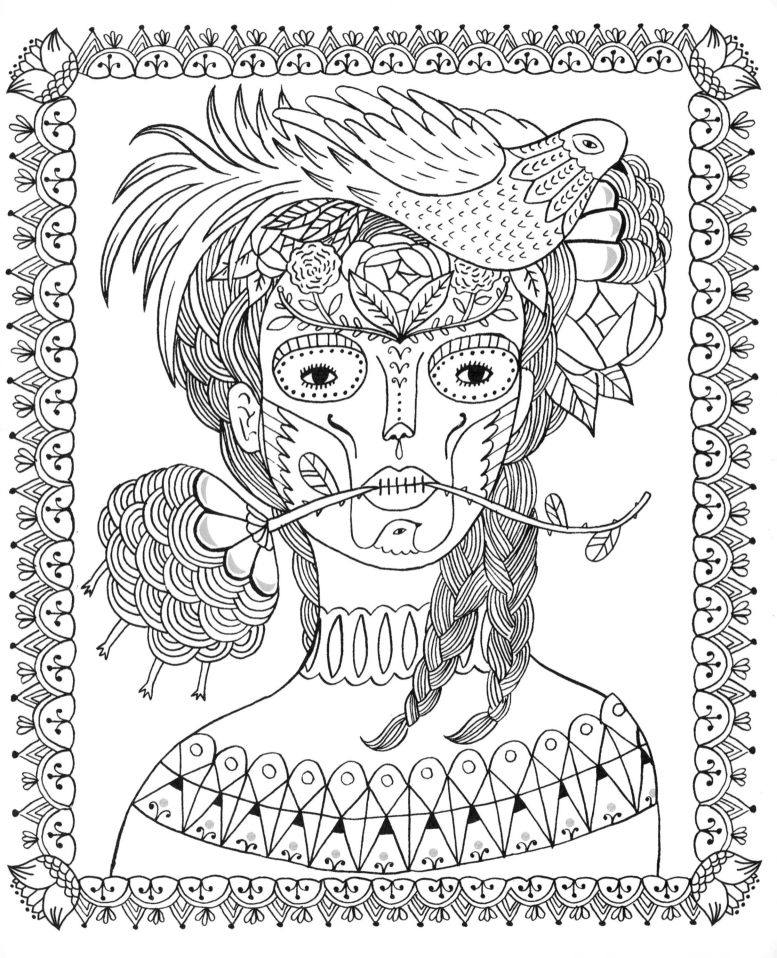

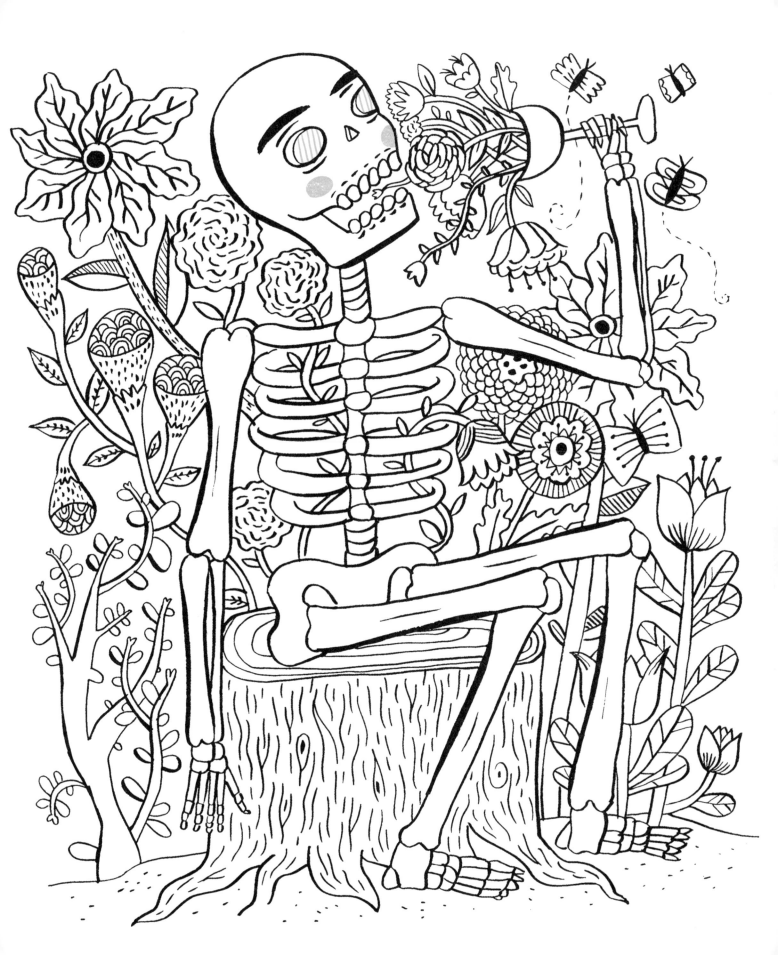

Sarah Walsh is a Kansas City–based artist and illustrator. She's inspired by animals, magical creatures, coffee, music, a good story, her friends and family, bravery, vintage children's books, and mid-century anything. Sarah has designed typefaces, illustrated for various card lines, dabbled in animation, and designed surface pattern. One of her favorite things about being an artist is that she gets to create a little world for someone to enjoy.

© 2014 Rockport Publishers
All images © 2014 Sarah Walsh

First published in the United States of America
in 2014 by
Rockport Publishers, a member of
Quarto Publishing Group USA Inc.
100 Cummings Center
Suite 406-L
Beverly, Massachusetts 01915-6101
Telephone: (978) 282-9590
Fax: (978) 283-2742
www.rockpub.com
Visit RockPaperInk.com to share your opinions,
creations, and passion for design.

10 9 8 7

ISBN: 978-1-59253-951-2

Cover and Interior Design: Debbie Berne
Cover Image: Sarah Walsh

Printed in China